T0069081

WILLEM DE KOONING

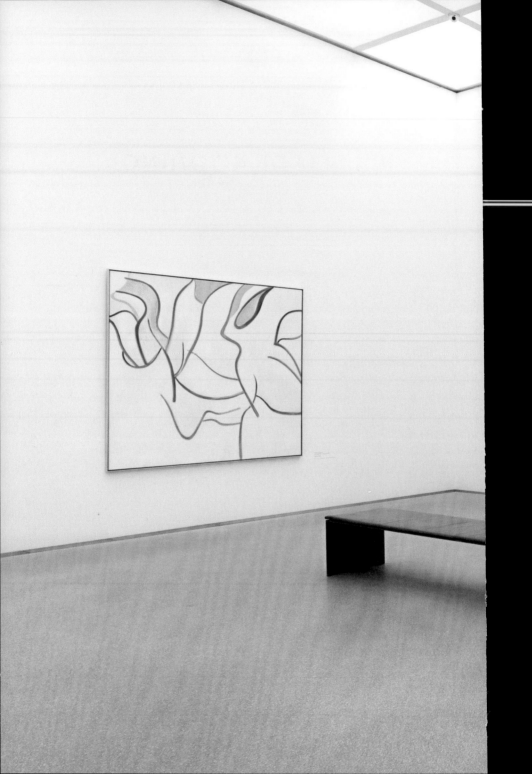

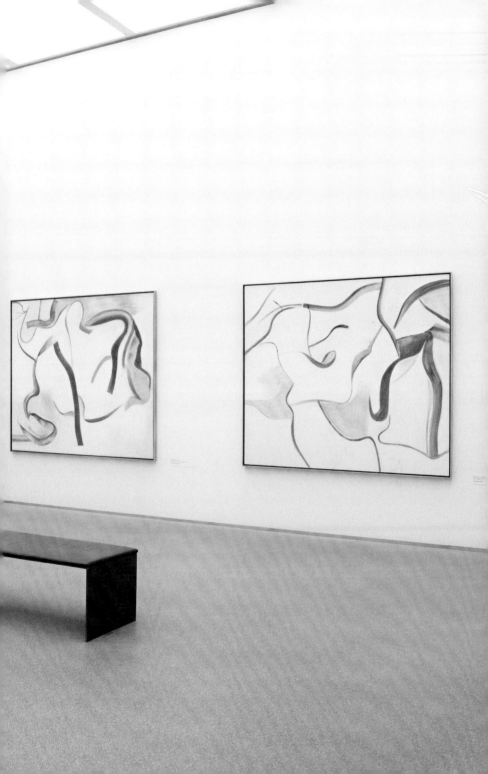

WILLEM
DE KOONING

Corinna Thierolf

HIRMER

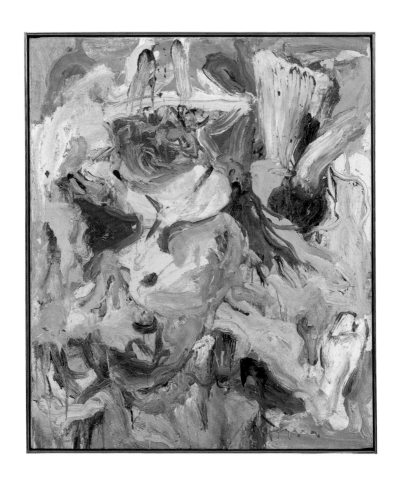

WILLEM DE KOONING

La Guardia in a Paper Hat, 1972, oil on canvas

141.1 × 122 cm, Private collection

CONTENTS

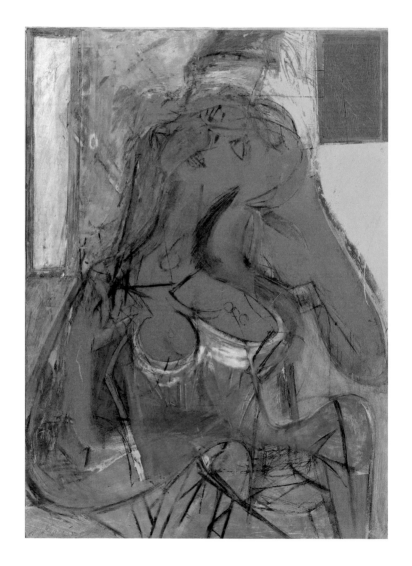

1 *Pink Lady*, c. 1944, oil and charcoal on card, 123 × 90.6 cm, Private collection

WILLEM DE KOONING: THE PICTURE AS AN EVENT

Corinna Thierolf

Willem de Kooning was one of the pioneers of modern American art. Having moved to the United States from Rotterdam, he is a representative of the group of painters who were born before or around 1910 and who moved to New York from various countries in America or Europe, such as Russia, Germany, France or, as in this case, the Netherlands, in order to create there what was later described as the "triumph of American painting". That phrase aims to describe the collective artistic achievement of the American artists who succeeded in asserting themselves despite the dominance of the Modernism that was mainly shaped in Paris. Along with Willem de Kooning this group was made up of the painters Stuart Davis, Arshile Gorky, Philip Guston, Jackson Pollock, Mark Rothko, Barnett Newman, Clyfford Still, Franz Kline, Robert Motherwell and others who were already being collectively labelled as "Abstract Expressionists" by the second half of the 1940s. Nevertheless this term describes the diversity and originality of Willem de Kooning's artistic works – as well as those of his fellow artists – only very generally. He in no way followed exclusively the Expressionist and abstract currents of early modernism in the style of Paul Cézanne, a development extending from Vincent van Gogh, Henri Matisse, Vasily Kandinsky and Piet Mondrian to Pablo Picasso and representatives of the Surrealist currents; he also drew on older traditions of Western art.

An example here is de Kooning's interest in individuals as different as Peter Paul Rubens and Jean-Auguste-Dominique Ingres. Furthermore de Kooning reacted precisely to his immediate environment, to the overwhelming variety presented by the city of New York, and then from the late 1950s also to the experience of landscape that he observed during his journeys or on Long Island, where he subsequently spent an increasing amount of time. He translated into his art phenomena that characterise urban life, such as speed and transience. It was rare for him to paint motifs with firm contours; instead the object and the environment merge with each other either in an aggressively destructive manner or by just blending.

STOWAWAYS

De Kooning was particularly appreciative of his own or other people's paintings when there was a "wonderful unsure atmosphere of reflection"[1] that was not domesticated by any desire to fit a certain style. He explained the reason for this in connection with a summary criticism of painters such as Kandinsky, Mondrian, the Futurists and Constructivists, about whom he said that they were always also pursuing a certain social goal with their works, a goal that they expressed in an encoded way in their motifs and in their style. In his view they were different because "some painters, including myself […] do not want to 'sit in style'. Rather, they have found that painting – any kind of painting, any style of painting – to be painting at all, in fact – is a way of living today, a style of living, so to speak. That is where the form of it lies. It is exactly in its uselessness that it is free. Those artists do not want to conform. They only want to be inspired."[2]

De Kooning viewed his own painting as an "event"[3], by which he meant to emphasise the "actuality" of every act of painting, suggesting that every painting captured a wealth of external and internal impressions that could never be retold completely and properly. His works have "no message"[4]; instead they demand exact observation with a willingness to discover the gestures, structures and colours contained in them individually so that the painting in turn can become an event for the viewer.

One of the characteristics of de Kooning's paintings is that they are "[derived] from other paintings"[5] – a line of investigation that is also pursued

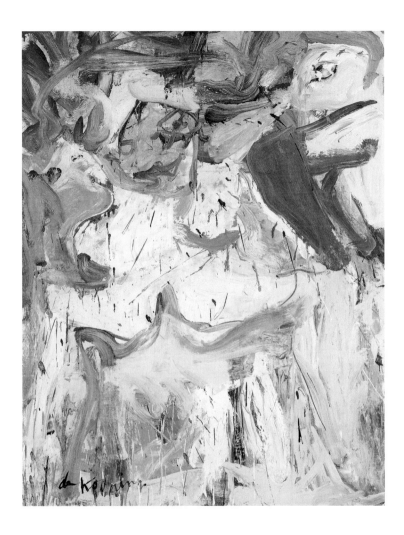

2 *The Visit*, 1966/67, oil on canvas, 152.4 × 121.9 cm, Tate Modern, London

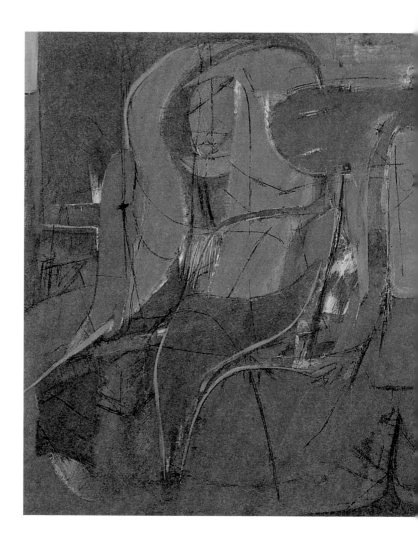

in the contribution starting on page 19. They are paintings from other eras, but the artist made their essence so much his own that the stimuli obtained from them travel in them in a hidden manner, like "stowaways"⁶, (*Stowaway* is also the title of a painting, 15) and appear in a completely surprising way. The references only become clear when viewers for their part penetrate deeply into de Kooning's art and its history and when they then pair this knowledge with free, un-academic association – an animating and irritat-

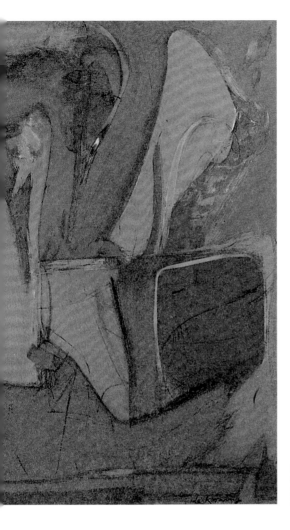

3 *Bill-Lee's Delight*, 1946
Oil on paper on card
70 × 87.7 cm
Private collection

ing dialogue that nevertheless – and this is visibly the artist's intention – hardly gives viewers final certainty.

De Kooning did not just make reference to paintings by others, but also to his own, examining and altering their results in terms of form and colour in extensive series of works, without recognising one specific variation as final or a series as complete at any given time. It is astounding, for example, how substantively he transformed the motif of women throughout

his creative period (p. 8; 1, 2). It even plays a demonstrable role in the process during which he created the paintings of his later years, which were frequently labelled as abstract.

The complex web in which de Kooning's paintings stand can therefore not be adequately characterised with terms such as "abstract" and "representational" either. "I don't really feel like a non-objective painter at all,"[7] he said in an interview in 1960. As emerges from further statements, he did not mean that he wanted to deny abstract ways of expression in his art; he only wanted to resist being pinned down to a style. And indeed, the color abstractions and the black and white abstractions (3, 4) that he painted during the second half of the 1940s were created at the same time as his figurative *Women* series. In the different series his characteristic signature manifests itself in ever new metamorphoses.

"A LITTLE BIT OUT OF THIS WORLD"

By the late 1960s de Kooning had developed painting into an intoxicating bacchanal of sensual gestures of colour, an "all-over" feast of aesthetic freedom, lavishly carnal and pointedly burlesque[8] association. Then, however, it receded into the background in favour of his preoccupation with sculpture. In the late 1970s he spent 2½ years working more slowly, exploring and developing his next style. He created a number of documented works but above all this was a period during which, supported by his wife Elaine, he dedicated himself successfully to battling his alcoholism and re-organising his studio. In 1981 de Kooning, then one of the few central artists of so-called Abstract Expressionism still alive (along with Robert Motherwell), embarked on his late works with new creative zeal.

In the pictures he painted now, energy was no longer "burnt"[9]; instead the energy available was seized and made visible in its main lines of force. The motifs appear in an ethereal atmosphere apparently moved by an intangible breath of air; they float, at times densely crowded, at other times at a detached distance, towards a balance that is free from any pressure. Pictures recording the "states" of these paintings reveal that de Kooning did not deliver the formal and colour-related purism of these works – often in the triad blue-yellow-red on a white background, or reduced to one or two colours – onto the canvas in an ad hoc manner; a phase of

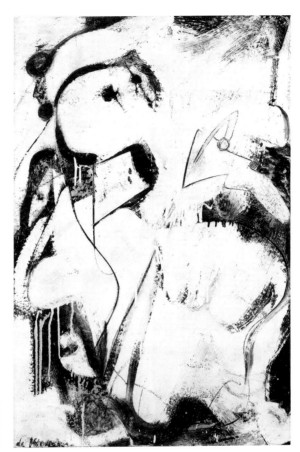

4 *The Moraine*
1947, oil on paper
on wood fibre
91.4 × 61 cm
Private collection

searching, rejection and rediscovery preceded these works too. But the final result is a captivatingly clear and bright, festive and arabesque ensemble of lines and stabilising fields of colour that advance the flow of movement like sails.

In light of the lyrical root of these late works we are reminded of the ornamental musicality in Henri Matisse's papercuts, of the elementary geometry in Piet Mondrian's late works and of works by de Kooning's close friend and fellow painter Arshile Gorky.[10] Indeed, it was never de Kooning's goal to leave the old behind. It was always part of his art, "Like a big bowl of soup. [...] you just stick your hands in it and you find something for

you."[11]. It was the transformation that attracted him. The pursued conquest of new levels of consciousness that are drawn from what is possible here and now is also the basis for the paintings he created when he was around 80 years old: during a period of his life when his thoughts may have lingered longer between heaven and earth, during which his memory became weaker. In 1989 he was examined by a physician and it was suggested that Alzheimer's disease was a probable cause of the symptoms of dementia.

De Kooning never cared about achieving an ideal wholeness to overcome reality.[12] Instead, liberating himself from the "train track"[13] of art history, from his own body of work and to some extent from himself was what drove him. "I'm in my element," he said as far back as 1960, "when I am a little bit out of this world".[14]

1 Willem de Kooning, "What Abstract Art Means to Me", lecture for a symposium in the Museum of Modern art on 5 February 1951. First published in: *The Museum of Modern Art Bulletin*, vol. XVIII, no. 3, spring 1951, pp. 4–8; Accessed at http://www.dekooning.org/documentation/words/what-abstract-art-means-to-me (accessed on 30 January 2018).
2 Ibid.
3 Harold Rosenberg, "Interview with Willem de Kooning", published in: *Art News*, vol. LXXI, no. 5, September 1972, pp. 54–59.
4 Ibid.
5 Cf. here for example the comparisons of works by de Kooning with those by Albrecht Dürer, Nicolas Poussin and Pablo Picasso, in: John Elderfield, *de Kooning a Retrospective*, exh. cat. New York 2011, pp. 15, 23.
6 The term "stowaway" has special significance for de Kooning. Fifty years after his illegal crossing as a stowaway in the engine room of a ship to America he created a painting with that same title, see pages 30/31.
7 Willem de Kooning: "Content is a glimpse…", *Location* (Spring 1963) pp. 45–48.
8 "I have a lot of cartoonist in me," de Kooning is quoted by Mark Stevens and Annalyn Swan as having said in *De Kooning. An American Master*, New York 2004, p. 50.
9 Cf. here John Russel's comment in the *New York Times*: "These are 'late' paintings, inasmuch as he may no longer have energy to burn in the way that he had twenty years ago." John Russel, "Art: A Lively Competitor to the Old de Koonings", in: *The New York Times*, 26 April 1982, p. 23.
10 Cf. for example Klaus Kertess, "Further Reflections", in: *Willem de Kooning. The last Beginning*, exh. cat. New York 2007, pp. 13–24.
11 Willem de Kooning, *Soirée, July 1959, 8th street*, unpublished transcript of a conversation between Willem de Kooning, Michael Sonnabend and Robert Snyder, July 1959, recorded by Marie-Anne Sichère, courtesy of The Willem de Kooning Foundation, New York.
12 Cf. his statement in Rosenberg 1972 (see note 3).
13 Willem de Kooning, "The Renaissance and Order", *trans/formation* 1, no. 2 (1951), pp. 85–87.
14 Willem de Kooning, quoted in: Robert Snyder, *Sketchbook No. 1: Three Americans*, New York 1960, n. p.

WILLEM DE KOONING
AND
THE GRIN OF THE CAT

Corinna Thierolf

In his story *Alice's Adventures in Wonderland* Lewis Carroll describes how Alice repeatedly encounters a cat sitting in a tree during her dream adventures. Like a sphinx it gives the girl cryptic clues about her onward journey and, just as mysteriously as it appeared, disappears again every time the message has been passed on. The cat, according to the story, vanished "beginning with the tail, and ending with the grin. Wasn't that a curious thing? A Grin without any Cat?"[1] Willem de Kooning used this example in 1972 to illustrate how the influence of other artists manifested itself in his own work: "If I am influenced by a painter from another time that's like [...] the smile left over when the cat is gone. In other words I could be influenced by Rubens, but I would certainly not paint like Rubens."[2]

Anyone who looks at paintings by de Kooning is repeatedly surprised by such a grin, and quite abruptly too. At least that was the case for me. This smirking was so unexpected because the paintings I could not help thinking of did not feature in the discussion surrounding de Kooning's art. Most recently I had such an intuition when I was looking at *Woman II* (5) from the Museum of Modern Art in New York. My attention was initially captured by the large eyes and was then steered to the majestically spreading figure of this woman, who may or may not be wearing a crown and who blends with her surroundings without clear contours. "The picture

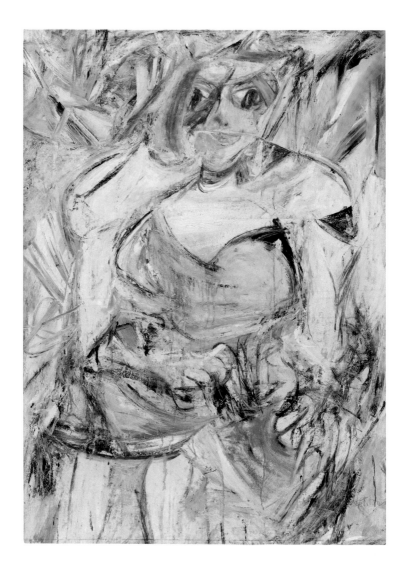

5 *Woman II*, 1952, oil, enamel and charcoal on canvas, 149.9 × 109.3 cm
The Museum of Modern Art, New York

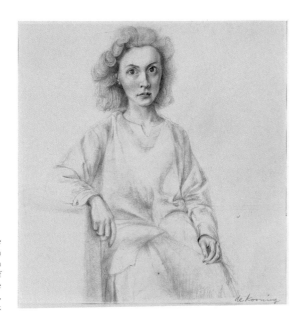

6 *Portrait of Elaine*
c. 1940/41, pencil on
paper, 31.2 × 30.3 cm
Courtesy of
The Allan Stone
Collection,
New York

looks like a pizza," my daughter said, and in doing so described the startling fact that the motif and ground (like dough and topping) become both a visually appetising and – in the physical depiction – a diffuse surface. Only the eyes and cleavage stand out as particularly "tasty" elements. The crystalline zigzag lines in the top left – possibly hints of an expansive mountain landscape – link up with the spiky structure on the head. The volume of the body cannot be determined exactly because of the large number of lines. An "inner" body, almost matching the neck in size, is, in a physiologically inexplicable manner, joined up to an oversized shoulder area above. This area in turn transitions into the greenish-blue or blue mixed with white at the edges of the painting. What a difference between this depiction of a woman and the likeness of Elaine de Kooning (6) from ten years earlier, in which the physical wholeness of the body and the peculiarities of the face are captured with devoted exactitude. In the later work, on the other hand, we struggle to determine what the woman we believe to make out in the picture really looks like, and whether she is sitting, and if so, where.

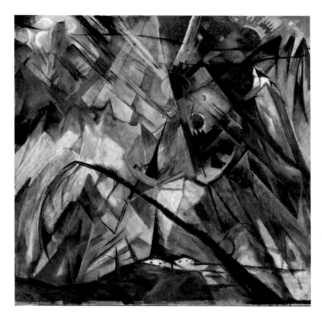

DREAM RAMBLING IN
DE KOONING'S LATER PICTURES

I was looking at *Woman II* in around the same way you would stare medi-
tatively at the surface of a body of water, and suddenly I saw Franz Marc's
Tyrol (7) from 1914 smiling at me from de Kooning's painting. This un-
expected affinity was probably established by the crystalline shapes on the
left-hand side of de Kooning's work, by the jagged structure on the head of
the woman depicted and in particular by the synthesis of person and land-
scape that can only become a unit in our feelings, in our vision. It is exactly
this that recurs in Franz Marc's painting.

Tyrol depicts a high mountain landscape in the midst of which the Virgin
Mary and the Infant Jesus appear. The head of the female figure is rep-
resented as a black circle in front of a central sun. At the same time the
black mark heralds the magical moment of a solar eclipse. The rays in the
background surround her head like a crown and join inseparably with the
jagged up-and-down of the mountain landscape. Mary's body grows in
part out of a mountain, while in part it also seems to stand transparently

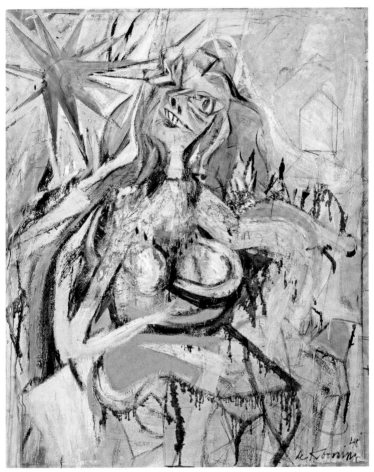

8 *Woman*, 1948, oil and enamel on fibreboard, 136.1 × 113.2 cm, Hirshhorn Museum and Sculpture Garden, Smithsonian Institution, Washington, DC

in the air like rays. The current state of the painting is the result of a reworking: Marc had initially conceived *Tyrol* as a pure landscape painting and had exhibited it as such in the Berlin Autumn Salon in 1913. Dissatisfied with the (relative) naturalism of the painting he took it back and reworked it with the additions that captivate us in such a special way today. There is no proof as to whether de Kooning knew Franz Marc's *Tyrol*, but the comparison between these and other paintings confirms how familiar

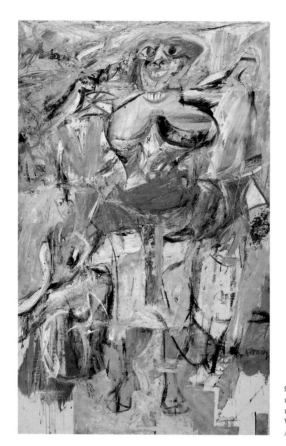

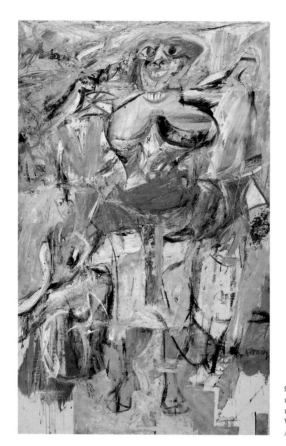

9 *Woman and Bicycle*
1952/53, oil on canvas
194.3 × 124.5 cm
Whitney Museum of
American Art, New York

he was with the fragmentation of pictorial motifs – a technique initially developed in Cubism at the start of the twentieth century. He will also have liked the merging of the figure with the motifs of nature in Marc's work, something characteristic of the latter's art. In *Woman* (8) from 1948 the far-reaching rays of the sun on the left, the pyramidal positioning of the woman, the crossing diagonals at the centre of the picture as well as a partially Cubist fanning out of the motifs are all reminiscent of *Tyrol*. The black tree silhouettes on the yellow hill on the right bring to mind the trees charred to leave behind nothing but a shell in Franz Marc's picture. In addition, the dark, burning power of the sun is addressed, because the motif is depicted in dark grey. Furthermore we can make out layered solar motifs

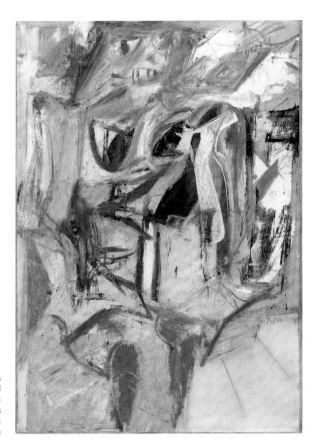

10 *Woman,* 1953
Oil, enamel and
charcoal on
paper on canvas
74 × 54 cm
Glenstone

in both works. In de Kooning's painting, the outlines of a smaller circle
have been deliberately left below the sun to the left – a repetition that can
also be found in the head of Mary in Franz Marc's work. Further examples
of heightening the expression by repeating motifs can be seen in other de
Kooning works, such as *Woman and Bicycle* (9) from 1952/53. In it he shows
the wide mouth – one that is reminiscent of the grinning cat by the way –
twice, one below the other. In *Woman* (10) from 1953 the pair of eyes is
depicted twice in different sizes. We find the same approach in *Woman* (11)
from three years earlier. By multiplying the motif we encounter a surreal
multiple depiction of the content, because the lower pair of eyes is where
the breasts belong. This approach is also reminiscent of Marc. The sun in

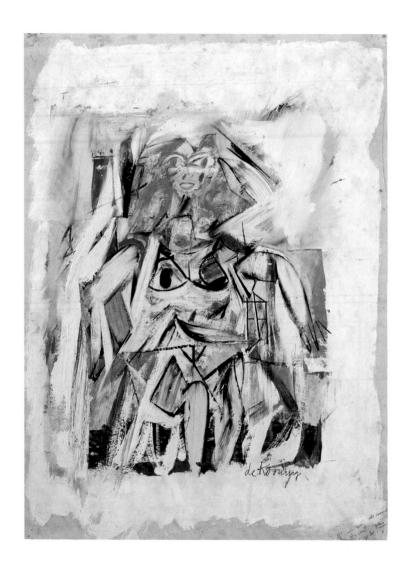

11 *Woman*, 1950, oil on paper on card, 37.5 × 29.5 cm
The Metropolitan Museum of Art, New York

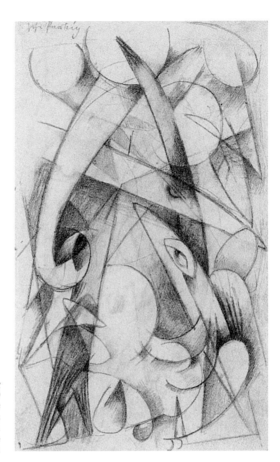

12 Franz Marc, *Sehr farbig
(Pflanzliche Formen)*
from: *Das Skizzenbuch aus
dem Felde*, sheet 9, 1915
Pencil, 16 × 9.8 cm
Staatliche Graphische
Sammlung, Munich

the middle and the heavenly body obscuring it also form Mary's head, while the landscape also makes up her body. As an example, the comparison of de Kooning's *Woman* (11) and Franz Marc's drawing *Very Colourful (Plant Forms)* (12) also reveals a comparable pictorial structure that tapers sharply to the top and has an eye appear in unexpected places.

However, in addition to the commonalities there are also some differences between the pictures. These include the painting style and certain artistic intentions associated with the pictures. The brushstrokes alone announce that Franz Marc wants to contribute to an implementation of an ideal goal with his painting. Every detail of his pictures has been precisely calculated

13 *Untitled XII*, 1982, oil on canvas, 177.8 × 203.2 cm
Collection Samuel and Ronnie Heyman

and is an irreplaceable part of a mosaic that has been completely thought through. His goal is not reproducing what the retina sees; instead he wants to capture the "absolute nature that lives behind the appearance". Marc is convinced that through abstraction, through what he called the "mystical inner construction" of his art he was reconquering a lost purity and unity for the world. He said "Faith in art in itself is missing. We want to build it."[3]

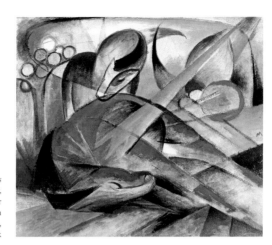

14 Franz Marc, *Träumendes Pferd*, 1913, watercolour, gouache and ink on paper 39.6 × 46.8 cm, Solomon R. Guggenheim Museum, New York

"I HAVE NO MESSAGE"

Putting himself into the service of ideas is the last thing de Kooning wanted to do. Every brush stroke was a departure to a new terra incognita for him; it has its "own point of view".[4] His paintings are full of contradictions. Again and again there are empty spaces or sudden U-turns that stem from new insights developed during the course of the painting process. He reacts at lightning speed and integrates the unexpected. Richard Shiff pointed out that de Kooning sometimes drew with two pencils at the same time or worked with his eyes closed, or that he turned the pages of an art book lying in the studio, accepting the chance stimuli. It was a pleasure to him to steer the perception into different, contradictory directions. These comparisons suggest that Franz Marc searched for *one* truth, while de Kooning saw a purpose in painting something that permitted *no* certainty. "I'm still working out of doubt." […] "I can change overnight."[5] In his interview with Rosenberg he said, "I have no message. My paintings come from other paintings. […] It is like an overtone of my woman paintings."[6] From his comments, of course we can conclude on the one hand that de Kooning's extensive knowledge of art history also included knowledge of Franz Marc. On the other hand de Kooning's artistic achievement is in large measure original, so that we as viewers cannot be sure of our associations any more. But since the grin of the cat continues to be in the room,

15 *Stowaway*, 1986
Oil on canvas
178 × 203 cm
Pinakothek der
Moderne, Munich
On loan from The
Willem de Kooning
Foundation, New York

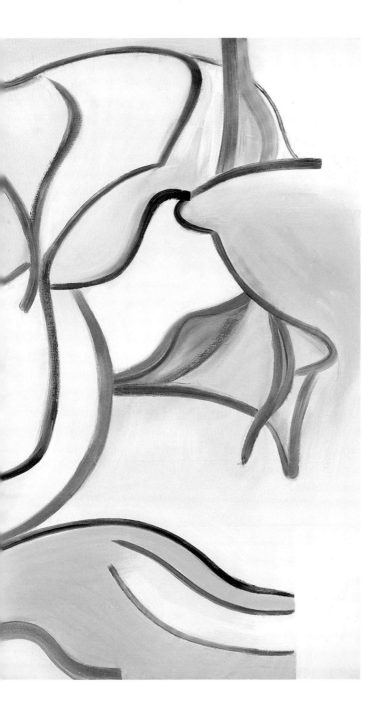

I am going to continue along this path of comparisons. If we compare de Kooning's 1982 work *Untitled XII* (13), as an example of the artist's later creative period, with Franz Marc's 1913 painting *Dreaming Horse* (14), a passage in which de Kooning commented on the depiction of a horse might come to mind: "I could paint the head of this horse. But that would be an abstract painting."[7] What arguments could be invoked as the basis for such connections that cannot be proved with certainty? De Kooning said of pictures by Rembrandt featuring several figures, on which a person is depicted and next to the person a black outline: "You know it is a man also. But if you look at that spot for a long time, there is no reason to think that it is a man. It happens with so many drawings and paintings [...] and

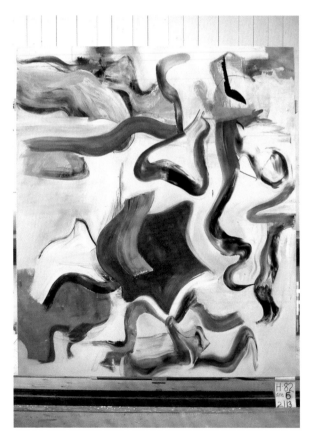

16 *Untitled V*
state 6 of 15,
13 February 1982
203 × 178 cm
The Willem de
Kooning
Foundation,
New York

all the works come together. [...] There seems to be something constant for me in painting."[8]

I want to expand our contemplation of de Kooning's works to include three examples that he created in around the mid-1980s (15, 18, 24); they differ from the early works in their lines, which seem to have been executed in a very controlled manner, and in the relationship between filled and empty pictorial space. There is no such emptiness in the earlier pictures. A flippant way to put it would be to say: the artist has de-cluttered! There are no alternative lines anymore, as we witnessed in *Woman II* (5). There used to be several outlines to choose from for an arm, to confuse our viewing experience; now every line is in the picture, reduced to its essential momentum.

De Kooning's compositions from this period are not the result of a single act of painting. Instead, the paintings are based on other pictorial ideas that are no longer relevant. This can be verified, for example, with the painting *Untitled V* (18), of which there are state photographs – snapshots of a painting process that often, as in this case and other cases, went on for months (16, 17). These photographs reveal that de Kooning frequently dis-

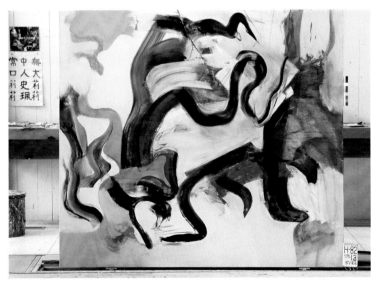

17 *Untitled V*, state 13 of 15, 22 May 1982, 178 × 203 cm
The Willem de Kooning Foundation, New York

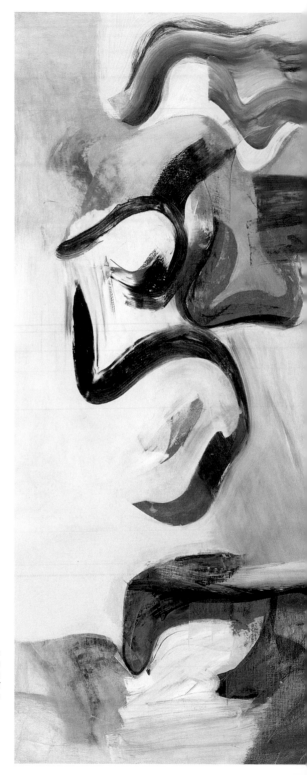

18 *Untitled V*, 1982
Oil on canvas
203.2 × 177.8 cm
The Museum of
Modern Art, New York

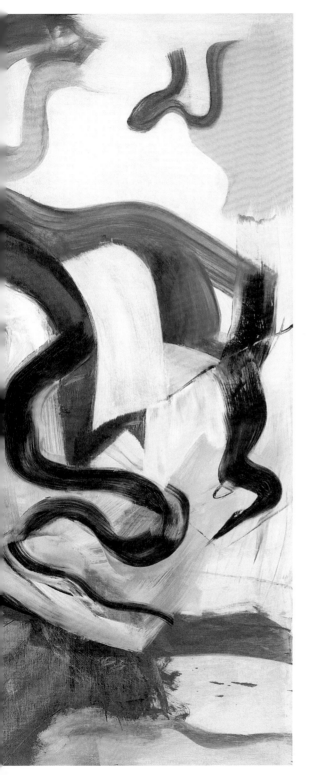

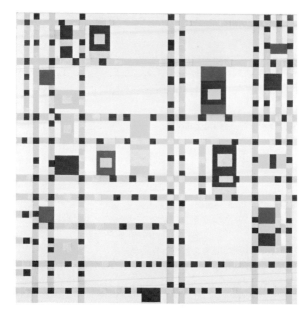

19 Piet Mondrian
*Broadway Boogie
Woogie*, 1942/43
Oil on canvas
127 × 127 cm
The Museum of
Modern Art,
New York

tilled the chosen forms that look so decisive in the final result from a large number of pictorial alternatives that were ultimately rejected. In the past he would have left such "alternatives" in the painting. What remains in the late works in the end feels like a Mondrian released from the right angle (19). Mondrian, over time, excluded everything organic, all curved lines from his works until in the end they consisted only of the contrasts between verticals and horizontals and – right at the end of his productive period – the primary colours red, yellow and blue. De Kooning said about him: "But Mondrian, that great merciless artist, is the only one who had nothing left over."[9] It would seem that in the late works mentioned above, de Kooning, the painter of the free gesture, translated the rhythm and the pulse that Mondrian evoked in his grid-dominated paintings into lines full of verve. In doing so he retrieved a fragment of painting, spontaneity and freedom from the bank of Mondrian's intellectual, purposeful art.

But let us leave the pictorial world created by Mondrian in New York in the 1940s and return to Franz Marc in Upper Bavaria. Let us be thoroughly confused by the Cheshire Cat. De Kooning too said: "It's all very puzzling, but I'm not a puzzle."[10]

In de Kooning's *Stowaway* (15) from 1986 we can see, along the lower edge of the painting and on the right-hand side in the upper centre, shapes and colours reminiscent of the dynamic animal silhouettes in Franz Marc's *Cows Red, Green, Yellow* (20) from 1911. However, regardless of how intellectually charged Marc's paintings are, they are also always "earthy". Viewers think they feel the gravity of the animals, their weight, and they are able to imagine the legs striking the ground after the bold leap. In de Kooning's paintings, on the other hand, the figurative allusions remain uncertain and the lines slip, leap, walk, fall and even fly out of the works to places unbeknown to us. Where do they go? In these paintings with their white ground we find ourselves in a placeless space, a "universe", because even the picture ground open towards the painting's edges gives us no spatial orientation. What we see cannot be assigned in the world of objects.

20 Franz Marc, *Kühe Rot, Grün, Gelb*, 1911, oil on canvas, 62.9 × 88 cm
Städtische Galerie im Lenbachhaus, Munich

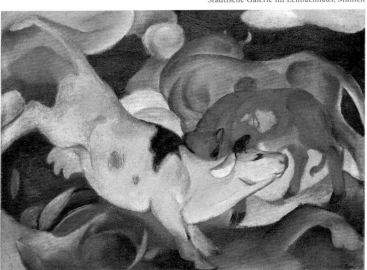

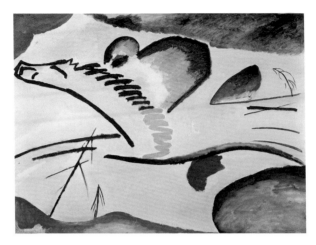

21 Vasily
Kandinsky
Lyrical, 1911
Oil on canvas
94 × 130 cm
Boijmans van
Beuningen
Museum,
Rotterdam

We can however intuitively take in the dynamism of the powerful lines in the picture, and the forces of the bright panels, and start our perception of the picture from there. In 1959 de Kooning described his state when he painted: "When I am falling, I am doing all right [...] when I am standing upright [...] I'm stiff. [...] I'm really slipping most of the time [...] I'm like a slipping glimpser."[11] In 1986 he said: "If you write down a sentence and you don't like it, but that's what you wanted to say, you say it again in another way. Once you start doing it and you find how difficult it is, you get interested. You have it, then you lose it again, and then you get it again. You have to change to stay the same."[12]

"SIMPLY REMAIN IN THE AIR"

De Kooning's ability to capture movement and the continuous flow of expression and perception bears a certain resemblance to Vasily Kandinsky's process for arriving at pictures, as is suggested by a further grin coming out of the pictures. In *Lyrical* (21) from 1911 the horse's forward momentum has been compressed into a single line that stands for the animal's entire body. The head, thrown upwards, and the small stick tree at the bottom portray the seemingly levitating powers of the rushing animal. The comparison of these lines of energy suggests that de Kooning was familiar with such a means of expression in Kandinsky and that he adopted it critically.

While I am not familiar with any sources describing the connection be-
tween Willem de Kooning and Franz Marc, in the case of Kandinsky we
can reconstruct that de Kooning knew his works comprehensively and in
the original from the 1930s onwards at the latest. He was in touch with the
Museum of Non-Objective Art that opened in New York in 1939 – this
museum later became the Guggenheim with its famous Kandinsky collec-
tion.[13] De Kooning summarised Kandinsky's art by saying that it was "too
theosophic" for him but that he nevertheless admired a few works a great
deal.[14] His biographers Mark Stevens and Annalyn Swan put it more pre-
cisely: "De Kooning did not like Kandinsky's mysticism but he was imme-
diately attracted by his fluent treatment of space and the captivating poetry
of his abstract figures."[15] These observations can be substantiated through
further comparisons between de Kooning's works and those of Kandinsky
from the early 1910s.

The blue line that is open to the bottom in the middle of *Untitled XLVII*
(24) from 1983 and describes a curve with a sensitive tilt to the right is
reminiscent of the head of a person whose body rises up weightlessly in
the middle while the cleverly painted brushstrokes on either side envelop
it like veils. As regards the abstract shape in the top of the picture that re-
sembles a head, it is worth making a comparison with Kandinsky's vocabu-
lary. He illustrated (22, 23) and theoretically described different expressive
variants of lines in his 1926 publication *Point and Line to Plane*. But as early
as 1913 the painting entitled *Small Pleasures* – now in the Guggenheim
Museum – exhibited slender figures leaning towards each other in the bot-
tom right-hand corner whose "heads" are reminiscent of the abstract line
in Kandinsky's drawing study in the top right, and of the blue contour line
in de Kooning's composition.

22, 23 Vasily Kandinsky, drawing studies for the book *Point and Line to Plane*, 1925

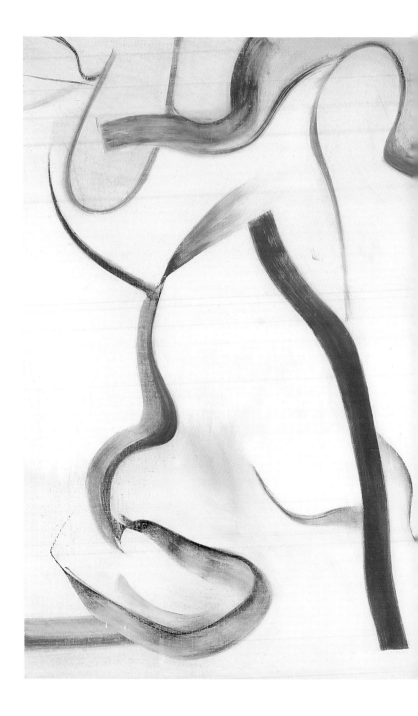

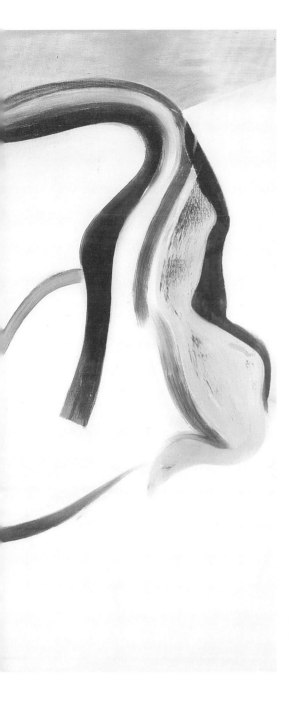

24 *Untitled XLVII*, 1983
Oil on canvas, 196 × 224 cm
Pinakothek der Moderne,
Munich, on loan from
The Willem de Kooning
Foundation, New York

25 Vasily Kandinsky
Small Pleasures, 1913
Oil on canvas
109.8 × 119.7 cm
Solomon
R. Guggenheim
Museum, New York

If we also compare de Kooning's *Untitled II* (28) from 1983 and Kandinsky's *Composition VI* (26) from 1913, then we find the characteristic lines (to the right of the centre of the painting and in the bottom left respectively) in them and we get the impression de Kooning allowed himself to be challenged to pictorial ping-pong, a game of variations, by the older paintings. The chosen shapes that initially appear coincidental to viewers turn out to be a motif for both artists that recurs several times.

In *Untitled V* (18) the motif is only introduced during the course of the painting process. The earlier stages document that de Kooning frequently turned the painting, worked on it from different sides and only determined a valid orientation at the end. In performing such experiments he was probably interested in the same thing as Kandinsky. Kandinsky had asked in *Point and Line to Plane* how the effect of the figure in focus here was changed by depicting it "upside down" or back to front. He also wanted to know how the suggestion of a rising force was awakened, something we can see in de Kooning too.[16]

The motif recurs once again in Kandinsky's complex *Composition V* (27) from 1911, which is given a rhythm by fine black lines. In the top right we can recognise it as a "head". It transitions into a shoulder line and ends surprisingly abruptly after a wide curve. This formation holds together the composition as if under the wings of an angel. The similarity to

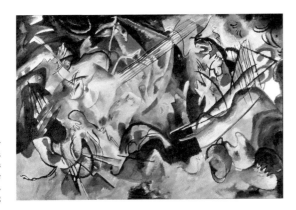

26 Vasily Kandinsky
Composition VI, 1913
Oil on canvas
195 × 300 cm, State
Hermitage Museum,
Saint Petersburg

de Kooning's chosen shapes is striking. He further heightens the impression of the sustained floating in space by the emptiness of the light pictorial ground. In addition de Kooning places the central red line, which demonstrates the hard conclusion already observed in Kandinsky, on to the canvas as a striking, free and also floating element. In view of this line that "simply remains in the air" we can think of de Kooning's enthusiasm for Vaslav Nijinsky. When this great dancer was once asked how he managed to stay in the air for so long that viewers thought he was suspended from something, de Kooning remembered that he answered: "You have to go up and then pause a little up there."[17] A wonderful moment like this is captured here.

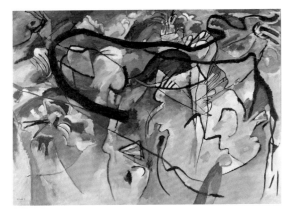

27 Vasily Kandinsky
Composition V, 1911
Oil on canvas
190 × 275 cm
Private Collection

next double page:
28 *Untitled II*, 1983
Oil on canvas
177.8 × 203.2 cm
San Francisco Museum
of Modern Art,
San Francisco, CA

29 *Untitled XXXVI*, state 1 of 7, 1983, 203 × 178 cm
The Willem de Kooning Foundation, New York

"YOU HAVE TO CHANGE TO STAY THE SAME"

Half the artist's life intervened between the *Woman* pictures described originally and the late works discussed here. Major developments and differences characterise the various creative periods and yet there is a striking continuity. The tension between the figure and abstraction as well as between the figure and space runs through his entire body of work as a central theme.

As we travelled from the Alps to America, previously unappreciated corresponding features in Kandinsky, Marc and de Kooning became clear. The Cheshire Cat mentioned further names of other painters in art history that we have not been able to address here. One of the most sonorous was

"de Kooning" himself, clearly referring to the inspiration that de Kooning derived not from other artists but from his own work. The astounding state photograph of a composition (29) from 1983 reveals that he began the painting during a creative phase nominally known as "abstract" with a rapidly drawn depiction of a woman that is stylistically reminiscent of the *Women* of the 1950s and 1970s. Beside the woman he clearly overcame his well-known *horror vacui* of the big white space – the space of the canvas. One brush stroke was enough for de Kooning in order to heighten the facial expression of the figure to a caricature, a further one to emphasise the expressive content of the body – and with that we have an "abstract" picture.

If, to conclude, we look at de Kooning's earlier pictures of women, such as *Woman and Bicycle* (9) from 1952/53, it becomes clear that it is the space that takes the figure apart – just like in his late works. It is the space that separates the figure from the ground. The space that in no way ends in the distant green landscape in the early picture and is in no way figuratively specified in the late one deconstructs the body or seamlessly merges with it. "One is utterly lost in space forever. You can float in it, fly in it, suspend in it […]",[18] de Kooning said in 1949. And elsewhere he said: "You have to change to stay the same."

CORINNA THIEROLF *is the chief curator at the Bayerische Staatsgemälde-sammlungen in Munich. As a consultant for post-1945 art, she has curated several exhibitions on artists including Joseph Beuys, Dan Flavin, Arnulf Rainer and John Chamberlain in the Pinakothek der Moderne as well as the summer exhibition "Königsklasse" in the New Palace on Herrenchiemsee. As an author and editor of publications she has focused, among other things, on American art and artists such as Andy Warhol, Fred Sandback, Dan Flavin, Arnulf Rainer and Fabienne Verdier.*

1 Lewis Carroll, *Alice's Adventures in Wonderland [& Through the Looking Glass, both with the Illustrations of John Tenniel & The Hunting of the Snark]*, London 1974, p. 63f. originally published by Macmillan and Company, London, 1890, p. 36.

2 Harold Rosenberg, "Interview with Willem de Kooning", published in: *Art News*, vol. LXXI, no. 5, September 1972, pp. 54–59.

3 Quoted from: Walter Hess, *Dokumente zum Verständnis der modernen Malerei*, Reinbek bei Hamburg 1995, p. 79.

4 Rosenberg 1972 (see note 2).

5 Richard Shiff, "Abstraction Not Abstraction," in *Willem de Kooning: A Centennial Exhibition* (New York: Gagosian Gallery, 2004), p. 9.

6 Rosenberg 1972 (see note 2).

7 Rosenberg 1972 (see note 2).

8 Rosenberg 1972 (see note 2), p. 280.

9 "What Abstract Art Means to Me: Statements by Six American Artists," *The Museum of Modern Art Bulletin* XVIII, no. 3 (Spring 1951).

10 Quoted from: *Willem de Kooning*, exh. cat. Stedelijk Museum, Amsterdam 1968, p. 81.

11 Willem de Kooning, *Inner Monologue*, unpublished transcript of a conversation between de Kooning, Michael Sonnabend and Kenneth Snelson, 1959, recorded by Marie-Anne Sichère, courtesy of The Willem de Kooning Foundation. Cf. edited excerpts from these recordings in: Robert Snyder, *Sketchbook No. 1: Three Americans*, New York 1960. Also quoted in Sarah Boxer op. cit. (see note 7).

12 Richard Marshall, *50 New York Artists: A Critical Selection of Painters and Sculptors Working in New York*, San Francisco 1986, p. 34.

13 De Kooning's friend John Graham, an artist and fatherly mentor of the Abstract Expressionists, was an important advisor to the eccentric Hilla Rebay who compiled more than 350 works, both for and with Solomon Guggenheim, mainly by Kandinsky, but also by Klee, Chagall and others, and who campaigned for the permanent positioning of these works in the city.

14 "What Abstract Art Means to Me: Statements by Six American Artists," (see note 9).

15 Mark Stevens, Annalyn Swan, *De Kooning. An American Master*, New York 2004, p. 165.

16 Wassily Kandinsky, *Point and Line to Plane. Contribution to the Analysis of the Pictorial Elements*, Munich 1926, 7th edition, Bern-Bümpliz 1973, pp. 94, 134.

17 Vaslav Nijinsky, quoted in Richard Buckle, *Nijinsky* (London: Weidenfeld and Nicolson, 1971), p. 92.

18 Willem de Kooning, "A Desperate View", lecture from 18 February 1949 for The Subjects of the Artist: A New School, in New York. Published for the first time in: Thomas B. Hess, *Willem de Kooning*, 1969, New York, The Museum of Modern Art, p. 15f.

BIOGRAPHY

Willem de Kooning
1904–1997

1904 Willem de Kooning is born in Rotterdam in the Netherlands on 24 April as the fifth child and only son of Leendert de Kooning and Cornelia, née Nobel. His father, a drinks wholesaler, and his mother, who works as a barmaid, separate when Willem is two years old. Three of his sisters die as toddlers, only his sister Maria Cornelia survives.

1907 The parents are divorced. Willem is initially assigned to his father, his sister to his mother; three years later he moves in with his mother.

1916/17 De Kooning starts a four-year apprenticeship with the advertising and interior-design company Jan & Jaap Gidding in Rotterdam. In 1917 he enrols in Rotterdam's art academy, the Academie voor Beeldende Kunsten en Technische Wetenschappen (known as the Willem de Kooning Academie since 1998), where he spends eight years attending evening lectures.

1920 He finds employment with Bernard Romein, the chief decorator of the Rotterdam department store Cohn & Donay. He becomes familiar with Art Nouveau and the De Stijl artist group established around Piet Mondrian.

1924/25 De Kooning travels through Belgium and studies at the Académie Royale des Beaux-Arts in Brussels. He works as a window dresser, cartoon and advertising-sign draughtsman among other things. After his return in 1925 he completes his studies in Rotterdam and decides to emigrate to America to earn money.

1926 With the help of his friend Leo Cohan, de Kooning travels to the United States on board the British steamship S.S. Shelley without valid papers; he arrives in Newport, Virginia, on 15 August. After an onward journey on board a ship to Boston he acquires legal immigration papers. He settles in Hoboken, New Jersey, and makes a living as a house painter.

1927–1935 De Kooning moves to New York in 1927 and spends the following eight years working as a commercial artist. He only finds time to paint at the weekends.

30 Willem de Kooning
(right) with a friend
on the ferry between
New York and
Hoboken,
New Jersey, 1926

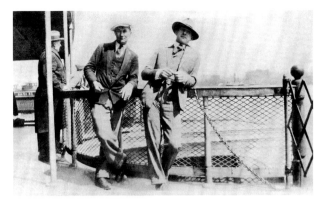

31 De Kooning (right) and Arshile Gorky
in the latter's studio in New York, 1934

32 In the studio on 22nd Street,
New York, c. 1938

33 Willem and Elaine de Kooning
in the studio, c. 1940/41

1929–1931 He meets the artists John Graham, Stuart Davis, David Smith and Arshile Gorky. Through his friendship with Gorky he meets the gallery owner Sidney Janis.

1934/35 De Kooning becomes a member of the newly founded Artists' Union. During the Great Depression the US government sets up the Works Progress Administration (WPA) for artists, in whose mural division de Kooning is accepted. He meets the art critic Harold Rosenberg, with whom he forms a lifelong friendship.

1936 De Kooning decides to leave the WPA in July because he does not have American citizenship. His work at the WPA has, however, affirmed his belief that he should now focus exclusively on painting. He starts with a series of pictures of standing and seated male figures. That autumn de Kooning is represented in the exhibition *New Horizons in American Art*, curated by Dorothy Miller, in the Museum of Modern Art. Quite by chance, he meets Mark Rothko on a bench in Washington Square Park – the beginning of a friendship.

1937/38 De Kooning is commissioned to design a wall in the Hall of Pharmacy for the World's Fair of 1939. He has his first encounters with the artists Philip Guston and Barnett Newman as well as with the art student Elaine Fried, with whom he enters a relationship. He produces his first *Women* series.

1939/40 De Kooning meets the artist Franz Kline, who becomes one of his closest friends. In addition to fashion drawings for *Harper's Bazaar*, de Kooning designs stage sets and costumes for the ballet *Les Nuages* at the Metropolitan Opera House.

1942 He meets Jackson Pollock, with whom he remains friends until the end of the decade. In his first group exhibition, which takes place in New York's McMillen Gallery, his works are displayed together with paintings by Jackson Pollock, Stuart Davis, Lee Krasner and Georges Braque as well as Pablo Picasso and Henri Matisse.

1943 De Kooning marries the artist, author and art critic Elaine Fried.

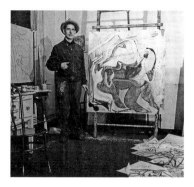

34 De Kooning in his New York studio on Fourth Avenue, 1946

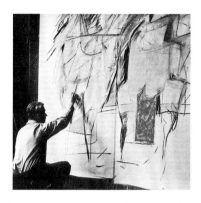

35 Working on one of his first designs for *Woman I*, 1950

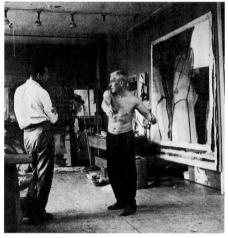

36 Willem de Kooning (right) in his studio with Thomas B. Hess, early 1950s

37 Portrait photograph in East Hampton, 1953

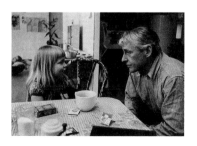

38 With his daughter Lisa in New York, 1960

1946–1948 He starts working on his black and white abstractions. On the occasion of his first solo exhibition in the Charles Egan Gallery, New York, in 1948, in which the pictures of his black-and-white series are displayed, the Museum of Modern art acquires his work entitled *Painting*. De Kooning takes part in the group exhibition *Annual Exhibition of Contemporary American Painting* in the Whitney Museum of American Art for the first time. At the invitation of Josef Albers, a former teacher at the Bauhaus and professor at the Black Mountain College, North Carolina, since 1933, de Kooning starts teaching visual arts there in the summer and uses the opportunity to intensify his relationship with John Cage, Merce Cunningham and Buckminster Fuller. He motivates his students to paint just a single picture over the course of the summer. Even though he is a representative of the latest abstract art, in his lecture "Cézanne and the Colour of Veronese" he describes to his audience his own profound interest in traditional painting. Arshile Gorky commits suicide, which deeply moves de Kooning. He starts his second *Women* series.

1949 In the Subjects of the Artists art school de Kooning gives the lecture "A Desperate View" and becomes a founding member of The Club, which hosts debating panels until the late 1950s. Together with artists such as Arshile Gorky, Hans Hofmann, Adolph Gottlieb, Barnett Newman and Jackson Pollock, de Kooning is regarded as one of the leading representatives of the first generation of the New York School, a term coined in 1946 by art critic Robert Coates. Attempts were made to categorise the main stylistic movements using terms such as Abstract Expressionism, Action Painting and Colour Field Painting.

1950 At the invitation of Alfred Barr, de Kooning exhibits four paintings, including *Excavation*, at the *25th Biennale* in Venice, which contributes to his international breakthrough. Following the biennale the painting is purchased by the Art Institute of Chicago. The art critic Clement Greenberg believes de Kooning to be one of the "most important artists of the 20th century". De Kooning is awarded the Logan Medal. He starts his third *Women* series. Josef Albert invites him to teach at the Yale School of Fine Arts and Architecture in New Haven in autumn.

1951 De Kooning takes part in the group exhibition *The Ninth Street Show*, curated by Leo Castelli, together with Franz Kline, Jackson Pollock, Robert Rauschenberg and other artists; the work he exhibits is *Woman* (1951).

1953–1955 The painting *Woman I* is purchased from the solo exhibition *Paintings on the Theme of the Woman* in the Sidney Janis Gallery, an exhibition which creates a furore in the art world because of its drastic depictions of women. Robert Rauschenberg requests a drawing from de Kooning for the purpose of erasing it. The work has since become known as *Erased de Kooning Drawing*. In 1954 de Kooning starts painting abstract urban landscapes. In 1955 Willem and Elaine de Kooning separate. They never divorce, however.

1956 Daughter Johanna Liesbeth (Lisa) is born at the end of January. The mother is Joan Ward, an illustrator, whom de Kooning had met in 1952. He starts an affair with the artist Ruth Kligman. Jackson Pollock dies in a car accident.

1957–1960 De Kooning starts painting abstract landscapes (until 1963) that are inspired by quick glances at the passing view during his drives from the city to the country. In 1958 he travels to Cuba and Italy with Ruth Kligman; in 1959 he takes part in the *documenta II* in Kassel with five of his works. He also spent a long time in Rome and, in a studio provided by Afro, produced a number of works titled individually with "Black and White Rome" plus a letter, A, B etc. De Kooning is one of the most celebrated artists of his time. At the same time a new generation of artists emerges in Jasper Johns, Robert Rauschenberg, Cy Twombly, Roy Lichtenstein and Andy Warhol, who postulate that Abstract Expressionism is over. During this period of transition de Kooning acquires a house in Springs, East Hampton on Long Island and gradually retreats from the city.

1962 De Kooning obtains U.S. citizenship. Franz Kline dies on 13 May.

1964 De Kooning moves to Springs definitively. The subject of landscape fades into the background and he devotes almost all of his efforts to the *Women* motif, which he paints on doors erroneously delivered to his studio (door paintings). He takes part in *documenta III* in Kassel with four works.

De Kooning moves permanently to the Springs, where he has designed and built a grand studio/residence.

1965 The first retrospective of de Kooning in America, featuring 55 works, takes places in the Smith College Museum of Art, Northampton, MA.

1966 Thanks to an extensive donation of works by de Kooning gifted by Joseph H. Hirshhorn, the Smithsonian Institution in Washington DC becomes the most important public collection with works by this artist. Because of his alcoholism, which has helped determine the rhythm of his life since the early 1950s, de Kooning has to be treated in hospital with increasing frequency. He starts a new *Women* series, which includes *Woman singing I.*

1968 In January de Kooning travels to Paris, where his first European solo exhibition is held in the M. Knoedler et Cie gallery. He is accompanied by Thomas B. Hess, the editor of *Art News*, and the gallery owner Xavier Fourcade. He meets Francis Bacon in London. On the occasion of his retrospective in the Stedelijk Museum in Amsterdam, de Kooning returns to the Netherlands for the first time since his emigration. The exhibition is subsequently shown in the Tate Gallery in London and then, in 1969, in the Museum of Modern Art in New York, the Art Institute of Chicago and the Los Angeles County Museum of Art.

1969 De Kooning spends time in Italy, including Rome, in June and July. He produces his first sculptures. From 1969 to 1974 he divides his time between painting, sculpture and lithography.

1970/71 De Kooning visits Japan in January, accompanied by Fourcade. The World's Fair in Osaka starts displaying works by de Kooning in March. In April Henry Moore visits him in Springs. Presumably inspired by his trip to Japan, de Kooning focuses increasingly on lithography. During a dinner he meets Emilie Kilgore (Mimi), with whom he begins an affair. The exhibition *Seven by de Kooning* takes place in the Museum of Modern Art in late 1970/early 1971.

39 In his studio in
East Hampton, 1975

40 Emilie Kilgore and
Willem de Kooning
in his studio, early 1970s

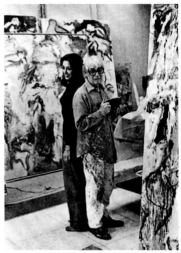

41 Elaine and Willem de Kooning
at the preview of the major
de Kooning retrospective in the
Whitney Museum of American Art
in New York on 16 December 1983

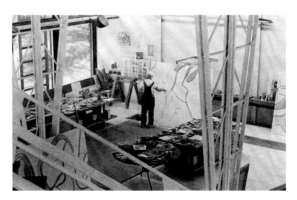

42 De Kooning in
his studio, 1985

1974 The National Gallery of Australia, Canberra, buys de Kooning's *Woman V* for $ 850,000, the largest sum ever paid for a work by a living American artist at the time.

1975 De Kooning embarks on a series of abstract landscapes that are notable for their great wealth of colour nuances and their expert paint application. A phase of high, often frenzied productivity begins which lasts until 1979.

1978 The Guggenheim Museum in New York puts on the exhibition *Willem de Kooning in East Hampton*. The first retrospective of Abstract Expressionism, with works by de Kooning and fourteen other artists, takes place in the Whitney Museum of American Art in October 1978. Harold Rosenberg and Thomas B. Hess die in quick succession; both of them were close companions and friends to de Kooning for decades. Over a lengthy process Elaine and Willem de Kooning become closer to each other again.

1979–1980 Elaine supports de Kooning in his battle against alcoholism, which he manages to overcome in 1980 until the end of his life, apart from a relapse in 1985. His short-term memory starts causing him problems. Initially no more than a suspicion, his condition is interpreted as the early stages of Alzheimer's. Tom Ferrara becomes his assistant in 1980 and with Elaine starts taking care of the running of the studio.

1981 He begins a series of abstract paintings, transitioning from the dense style of the late 1970s to the pared-down style of the mid-1980s.

1982 The documentary *De Kooning on de Kooning* is screened in the John F. Kennedy Center in Washington in March as part of the "Strokes of Genius" series initiated by Dustin Hoffman. Xavier Fourcade presents the new abstractions for the first time.

1983/84 In honour of his 80th birthday the Whitney Museum of American Art organizes the major retrospective *Willem de Kooning: Drawings, Paintings, Sculpture*, the largest to date with 280 works, which subsequently travels to Berlin and Paris.

1985 During one of the most creatively productive years of his career de Kooning completes 63 paintings. In some of them he uses a projector to display earlier drawings on to the canvas and to translate certain elements from them into painting. His short-term memory becomes noticeably worse.

1986 Exhibition of paintings from the years 1983–1986 in the Anthony D'Offay Gallery in London.

1987 The gallery owner Xavier Fourcade dies. The Gagosian Gallery in New York holds the exhibition *Willem de Kooning. Abstract Landscapes. 1955–1963.*

1989 Elaine de Kooning dies on 1 February. De Kooning's daughter Lisa and John L. Eastman petitioned the New York Supreme Court to be appointed conservators of the property of Willem de Kooning, taking on the responsibility of managing de Kooning's business affairs. They apply for legal guardianship because of his mental deterioration. Once again a record sum is paid for the work of a living artist at Sotheby's, this time *Interchange* from 1955. De Kooning is awarded the *Praemium Imperiale* by the Japan Art Association.

1993 The Hirshhorn Museum and Sculpture Garden dedicates a large survey exhibition to de Kooning, which is then also shown in Barcelona, Atlanta and Boston.

1994 A major solo exhibition marks de Kooning's 90th birthday in the National Gallery of Art in Washington DC and also travels to the Metropolitan Museum in New York and the Tate Gallery in London.

1995/96 Works by the artist from the 1980s are shown on a large scale for the first time in the exhibition *Willem de Kooning. The Late Paintings* in the San Francisco Museum of Modern Art and then in the Walter Art Center in Minneapolis, in the Kunstmuseum Bonn and in the Museum Boijmans van Beuningen in Rotterdam.

1997 Willem de Kooning dies in his house in Springs on Long Island on 19 March at the age of 92.

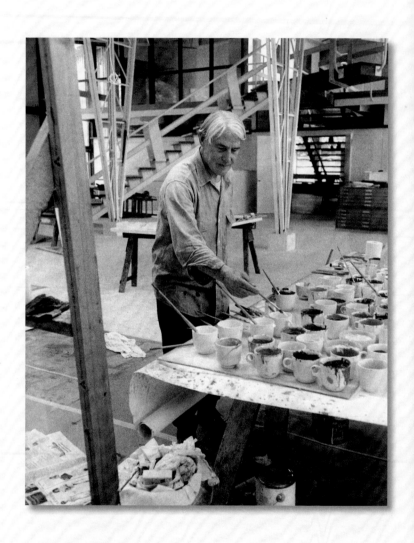

Willem de Kooning in his studio, 1966

ARCHIVE

Discoveries, Documents
1936–1983

I

In an interview with the BBC in 1960 Willem de Kooning spoke about his training and his early years as an artist. After his time at the Academy in the mid-1920s he did not move to Paris, the centre of the avant-garde, but to America, having heard that this was the place "where an individual could get places and become well off, if he worked hard". Immediately after his arrival he found work as a house painter, lived temporarily in a Dutch seamen's home and was "a Sunday painter working most of the time and painting once in a while". The shift only came for him in the mid-1930s. As part of the Works Progress Administration initiative, de Kooning and other artists designed murals for public buildings. Some studies for these commissions survive, but many are lost. Compositional elements of his works can also be found in various works on paper that he produced outside of the sponsored projects. Years later he said this period had been inspirational for him:

"But the year that I participated was such an enormous experience for me – that I produced paintings in order to earn a living – and I took a different attitude. After the project I decided to paint and do other jobs in order to earn a living. The situation remained the same but my attitude had changed."

2

Willem de Kooning's drawings play an important role within his œuvre. However, apart from a few exceptions de Kooning did not view his drawings as autonomous works of art produced for their own sake; instead they were for him a medium that inspired his painting and that represented the creative process. In the context of his Women *pictures produced between 1949 and 1954 he drew sketches of great impulsiveness and force that reflect his search "to see how far one could go". In his conversation with David Sylvester in 1960 he explained his thoughts about this:*

"The Woman became compulsive in the sense of not being able to get hold of it—it really is very funny to get stuck with a woman's knees, for instance. You say, "What the hell am I going to do with that now?"; it's really ridiculous. It may be that it fascinates me, that it isn't supposed to be done. [...]

1a

1b

1a *Study for the Williamsburg Project*, c. 1936, 23.7 × 36.5 cm
whereabouts unknown
1b *Untitled*, c. 1937, watercolours and pencil on paper, 22.4 × 39.7 cm
Whitney Museum of American Art, New York

I took the attitude that I was going to succeed, and I also knew that this was just an illusion. I never was interested in how to make a good painting. […] I was interested in that before, but I found out it was not my nature. I didn't work on it with the idea of perfection, but to see how far one could go—but not with the idea of really doing it."

3

De Kooning rejected being classified as belonging to a specific movement – to him, that was akin to a constraint:

"The idea of order can only come from above. Order, to me, is to be ordered about and that is a limitation," was the justification of his attitude in a lecture in New York on 18 February 1949."

He continued:

"Art should *not* have to be a certain way. It is no use worrying about being related to something it is impossible not to be related to. Style is a fraud. […] It is impossible to find out how a style began. I think it is the most bourgeois idea to think one can make a style beforehand. To desire to make a style is an apology for one's anxiety. […] You are with a group or movement because you cannot help it."

Willem de Kooning explained what he understood by abstract art at a symposium in the Museum of Modern Art in New York in 1951:

"Personally, I do not need a movement. What was given to me, I take for granted. Of all movements, I like Cubism most. It had that wonderful un-sure atmosphere of reflection – a poetic frame where something could be possible, where an artist could practise his intuition. It didn't want to get rid of what went before. Instead it added something to it. The parts that I can appreciate in other movements came out of Cubism.
Cubism *became* a movement, it didn't set out to be one. It has force in it, but it was no 'force-movement'. And then there is that one-man move-ment, Marcel Duchamp – for me a truly modern movement because it

2

2 [no title], 1950/53, pencil on paper, 30.5 × 23.5 cm, Private collection

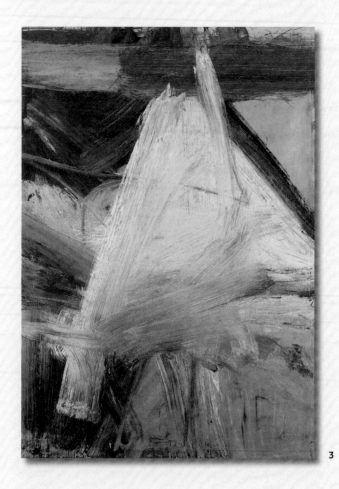

3

implies that each artist can do what he thinks he ought to – a movement for each person and open for everybody.
If I *do* paint abstract art, that's what abstract art means to me."

3 *Detour*, 1958, oil on paper on canvas, 150 × 108 cm
Pinakothek der Moderne, Munich

4

In a transcript of a conversation between Willem de Kooning, Michael Sonnabend and Robert Snyder, which took place in July 1959 and which has not been published before, de Kooning provides both pragmatic and inspiring insights into the creation of his art:

"No, I was talking about how an artist works. And so I said that I have to paint those figures…and I get a feeling like I came into a room someplace and I was introduced to someone, that for a fleeting second, like a glimpse I saw of somebody sitting on a chair. Then I have this glimpse of this thing this happening. And I got interested in painting that. Like frozen glimpse. That was my interest. That's not a new idea or…everything is already in art. That's like a big bowl of soup. Everything is in there already. And you just stick your hands in it and you find something for you. It's already there in art like in this…so in this stew…so the person has to go through it for himself. Like you meet those things also. Then I find out you get the idea and you think of something you can do within a few days, like a glimpse…and then you find yourself working on it for a year and another year and another year and before you know it, five years goes by to capture this…"

Years later, in a conversation with the art critic Harold Rosenberg in September 1972 de Kooning summarised the influence of artist colleagues in the following way:

"I am an eclectic painter by chance; I can open almost any book of reproductions and find a painting I could be influenced by. It is so satisfying to do something that's been done for 30,000 years the world over. When I look at a picture I couldn't care less for when it was done. […] I was lucky when I came to this country to meet the three smartest guys on the scene: Gorky, Stuart Davis, and John Graham. They knew I had my own eyes but I wasn't always looking in the right direction. I was certainly in need of a helping hand at times. Now I feel like Manet who said, "Yes, I am influenced by everybody. But every time I put my hands in my pockets, I find someone else's fingers there."

The sources of the quotations in this section can be found on p. 70
(Notes about the text sources in the Archive).

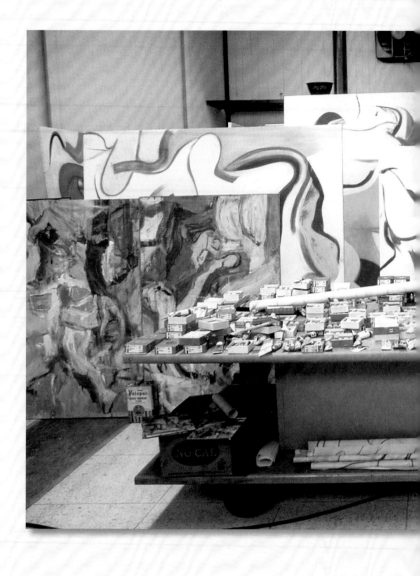

4 Paintings from the 1970s and 1980s in Willem de Kooning's studio
in East Hampton in 1983; the painting *Untitled XLVII* (pp. 40/41)
can be seen on the left.

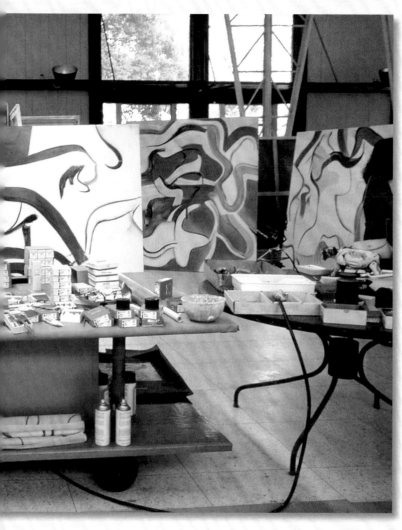

SOURCES

NOTES ABOUT THE ESSAYS BY CORINNA THIEROLF

Individual sections of the introduction "Willem de Kooning: The Picture as an Event" have been taken (and translated) from: Corinna Thierolf, *Amerikanische Kunst des 20. Jahrhunderts in der Pinakothek der Moderne*, Ostfildern 2002, pp. 214–223.
The text "Willem de Kooning and the Grin of the Cat" is based on a lecture given by the author in the Pinakothek der Moderne in Munich on 6 July 2012.

NOTES ABOUT THE TEXT SOURCES IN THE ARCHIVE

The quotations in the Archive section are taken from the following sources:

Page 62
Section 1:
Willem de Kooning, "Content is a glimpse…," *Location* (Spring 1963), pp. 45–48.
Irving Sandler, "Willem de Kooning: Conversation in de Kooning's Studio, 16 June 1959," *Museum Journal*, series 13, no. 6 (1968), pp. 285–290, translated from Dutch by Harry Cooper, August 6, 1993.

Section 2:
Willem de Kooning, "Content is a glimpse…," *Location* (Spring 1963), pp. 45–48.

Page 64
Section 3:
Willem de Kooning, "A Desperate View," in Thomas B. Hess, *Willem de Kooning* (New York: The Museum of Modern Art, 1968), pp. 15–16.
Willem de Kooning, text of talk delivered at a symposium at MoMA on February 5, 1951, first published in "What Abstract Art Means to Me: Statements by Six American Artists," *The Museum of Modern Art Bulletin* XVIII, no. 3 (Spring 1951), pp. 4–8.

Page 67
Section 4:
Willem de Kooning, Michael Sonnabend, Robert Snyder, Harold Rosenberg, Franz Kline, Herman Cherry, Tom Hess, and Ludwig Sanders, "Soiree," July 1959, transcribed by Marie-Anne Sichere.
Harold Rosenberg, "Interview with Willem de Kooning," *Art News* 71 (September 1972), pp. 54–59.

Published by
Hirmer Verlag GmbH
Nymphenburger Strasse 84
80636 Munich
Germany

Front cover: *Untitled XLVII*, 1983, oil on canvas,
Pinakothek der Moderne, Munich, on loan from
The Willem de Kooning Foundation, New York
Double page 2/3: installation photograph of works
by Willem de Kooning at the Pinakothek der
Moderne, 2009, from left to right: [no title], 1985,
oil on canvas, 195 × 223 cm; *Untitled XLVII*, 1983,
oil on canvas, 195 × 223 cm, both Pinakothek der
Moderne, Munich, on loan from The Willem de
Kooning Foundation; [no title], 1984, oil on canvas,
195 × 223 cm, Private collection
Double page 4/5: [no title], 1985, oil on canvas,
195 × 223 cm, Pinakothek der Moderne, Munich,
on loan from The Willem de Kooning Foundation,
New York

All artwork by Willem de Kooning
© 2018 The Willem de Kooning Foundation /
Artists Rights Society (ARS), New York /
VG Bild-Kunst, Bonn

© 2018 Hirmer Verlag GmbH and the author

www.hirmerpublishers.com

Bibliographic information published by the
Deutsche Nationalbibliothek
The Deutsche Nationalbibliothek lists this
publication in the Deutsche Nationalbibliografie;
detailed bibliographic data are available on the
Internet at http://dnb.dnb.de.

TRANSLATION
Michael Scuffil, Leverkusen
Josephine Cordero Sapien, Exeter

COPY-EDITING/PROOFREADING
Jane Michael, Munich

PROJECT MANAGEMENT
Gabriele Ebbecke, Munich

DESIGN/TYPESETTING
Marion Blomeyer, Rainald Schwarz, Munich

PRE-PRESS/REPRO
Reproline mediateam GmbH, Munich

PAPER
LuxoArt samt new

PRINTING/BINDING
Passavia Druckservice GmbH & Co. KG, Passau

[no title], 1985 (pp. 4/5) and *Untitled XLVII*, 1983
(pp. 40/41) have been on loan to the Bayerische
Staatsgemäldesammlungen / Pinakothek der
Moderne, Munich, from The Willem de Kooning
Foundation, New York, since 2008 and *Stowaway*,
1986 (pp. 30/31) since 2010.

**This publication has been produced with the
support of**

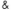

INTERNATIONAL PATRONS OF THE PINAKOTHEK E.V.

We would like to thank:
Amy Schichtel, the executive director of
The Willem de Kooning Foundation in
New York, and colleague Dina Georgas for
their dedicated support with the research
for this publication.

ISBN 978-3-7774-3073-7

Printed in Germany

THE GREAT MASTERS OF ART SERIES

ALREADY PUBLISHED

www.hirmerpublishers.com